Before Life Hurries On

Sabra Field

Josephar Linpelbach

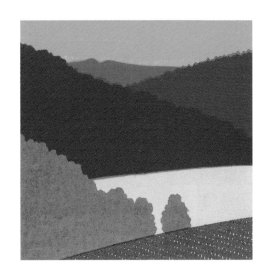

Before Life Hurries On

by Sabra Field
and Jenepher Lingelbach

University Press of New England

HANOVER AND LONDON

University Press of New England, Hanover, NH 03755

Text © 1999 by Jenepher Lingelbach

Illustrations © 1999 by Sabra Field

Printed in the United States of America

5 4 3 2 1

CIP data appear at the end of the book

To Our Children

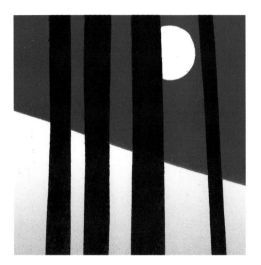

"I only went out for a walk,

and finally concluded to stay out till sundown,

for going out, I found out,

was really going in."

John Muir, *Words from the Land*

CONTENTS

PROLOGUE

This book celebrates special natural places, for their beauty and for their healing of the human spirit.

For humankind, a growing gap between our inner selves and outer selves —an imbalance between how we live our lives and how we would like to live them—leaves the spirit thirsting for renewal. For many, renewal and re-creation come with time spent in the natural world. Through word and image, we hope to create connections to special places that seep into the soul. In feeling the spirit of place, we reconnect with the spirit of self.

At first glance, our portrayals may say "all is well, pass on by." But they offer an invitation to pause and enjoy, to reflect on your own experience. Each scene in this book captures a poignant time that becomes a metaphor for more than that single moment.

Motivating each of us is a deep gratitude and love for the rural landscape, molded by human and wild life, which surrounds us in Vermont. Propelling each of us is our fascination with the designs of nature—countlessly varied in form and function, marvelously efficient and awesome to observe.

The human spirit and the open landscape are inextricably connected. They come together in this book, created as a prayer for the well-being of the land and of the human spirit.

Poems and Images

Double Lives

Why, when I love the woods' cool solitude
Where leaves cast shadow shapes on leaves beneath
And frame the patchwork of the sky above,
Do I feel a peace and deep well-being
When I step into the light
And see the valley—farms, houses, fields—below?

Does the chaos and aloneness of the woods,
Where life and death lie littered on the forest floor,
Awaken need for order
In those tilled and tended places?

Like the frog and salamander we live double lives,
Thriving in both wild and settled spaces.

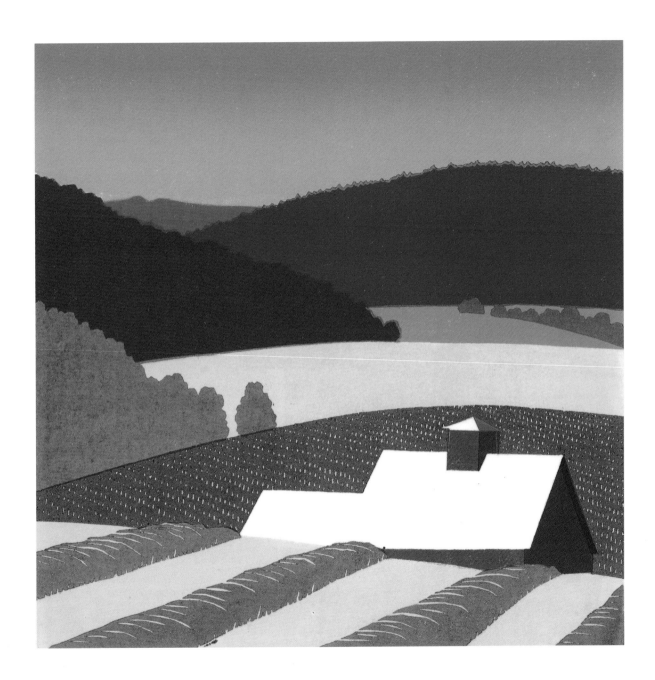

Morning Pond

Tranquillity and tumult stalk the morning pond
 where ripples overlap themselves to reach the shore
 and cattail leaves leave shadows
 upside down and wavering
 where angles broaden in a beaver's wake
 and shock waves radiate
 from its smack-slapping tail
while a ragged-crested kingfisher
 chatters, querulous,
 and plunges from its branch
 to grab a silver-shingled minnow.

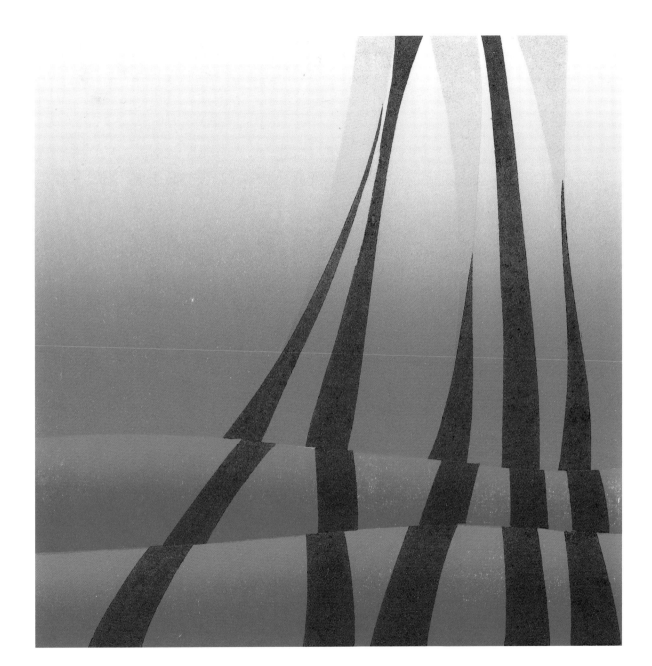

Mountain Top

The wind gusts fierce, herding sheep-like clouds
That send stray shadows over deep green woods
 in undulating patterns.
Ponds glisten on the valley floor,
 black water rippled gold.

A raven krawks, its diamond tail flared wide,
And disappears beneath a cliff.
Twitters seep from dwarfed misshapen trees—
Songbirds from the waistline of the hemisphere
Nesting in the north.

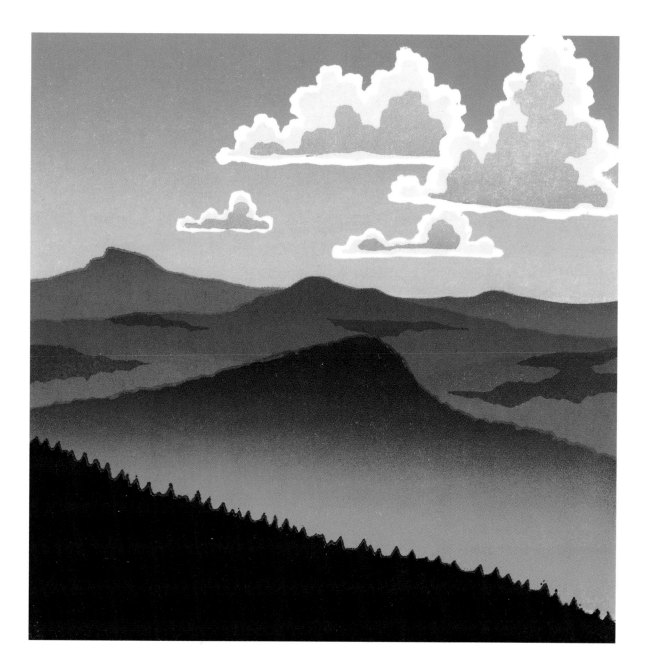

Autumn Dawn

Wooded dawn-blue hills
Cushioned by soft fog
Stage the brilliant pirouette
 of orange leaves
Against the rising sun.

There is time
To savor moments in the dawn
Before life hurries on.

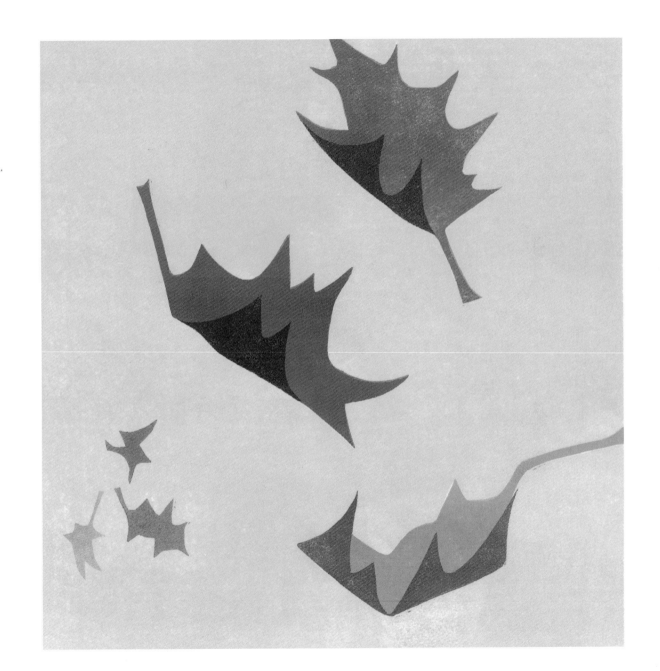

November Fog

Fog hangs like silver gauze
And curtains off the distant world
Yet displays in stark relief
The naked silhouettes of oak and elm.

Rows of corn stalks fade away.
But imperceptibly, as Polaroids come clear,
Geese caught among the stubble
Emerge like figures on a tapestry.

Sometimes when grayness screens
All but bold design,
We search with greater urgency
For signs of other life.

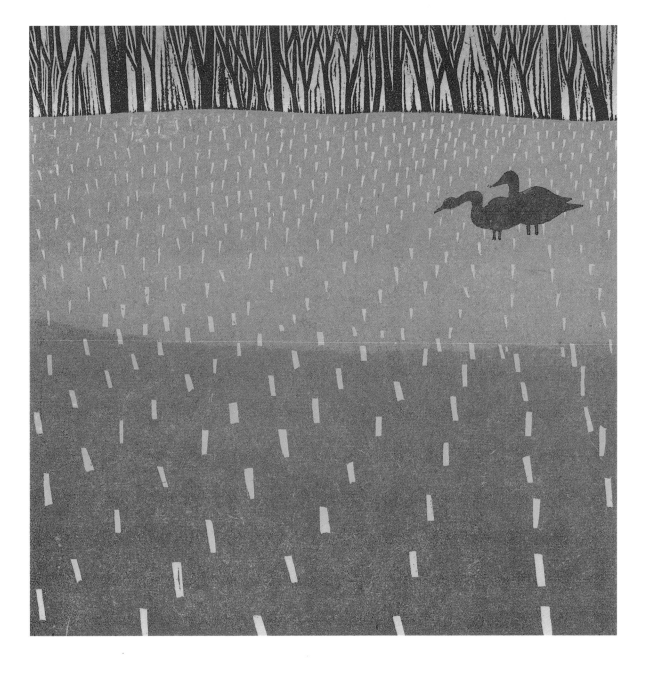

Early Winter

In early winter the forest whispers "sleet"
When ice drops skid on dried beech leaves
That cling to twigs, slightly hunched,
Like hibernating bats.

The snow tells secrets too.
Single toe prints edge along the trees;
Paired leaping tracks hurtle towards the wildest woods.
Sharp-eared fox and fierce-eyed fisher
On their predatory rounds.

In such places, at such times, life is sparse.
Even subtle signs delight a darkness-weary soul.

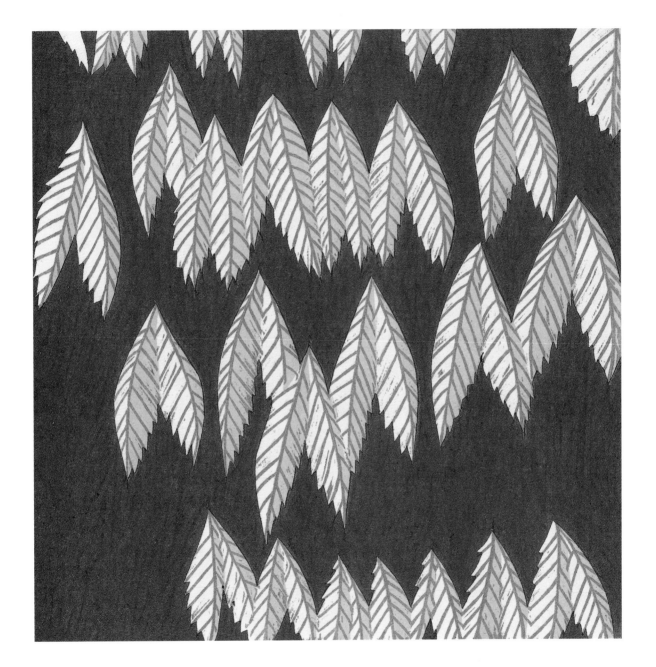

Full Moon Night

No human light, no human sound,
Expansive quiet all around.
From woods' edge, floating on the field
Tree silhouettes to contours yield.
Distant hills are white and black
Bar-coded woods against snow pack.

Awed to see in the brilliant light
Of smooth white snow on full moon night
Skiers climb with shadows bold
And steaming breath in bitter cold,
Thrilled they dared to venture forth
In a frozen world, far from the hearth.

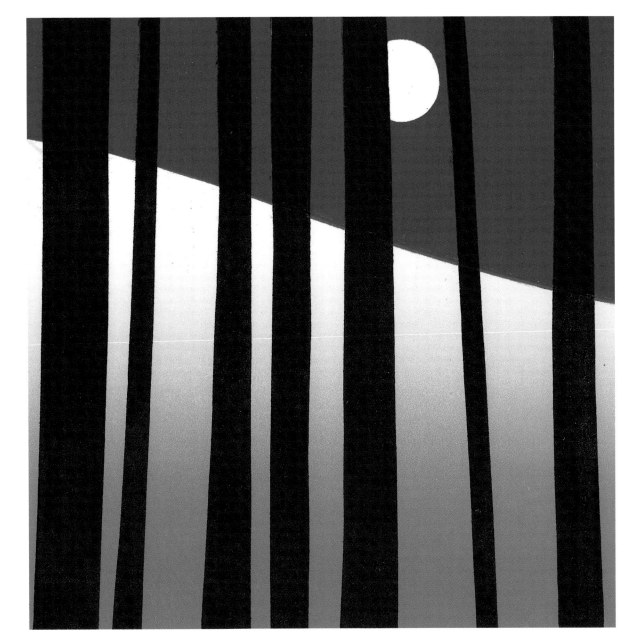

Winter Storm

Snow sweeps towards the woods and pelts the stiffened trees
Or swirls in corkscrew eddies upward.
An owl, stone still, hunkers on a branch,
Invisible to snowed-under prey
That unwittingly may surface.

Deep snow cushions and protects the little ones,
Holding in earth's waning warmth.
It may drag down the bigger ones
Who flounder when they move
Or starve if they do not.
Nature triumphs whether one survives or dies.

It is against the wildness of the place
That the harsh beauty of the storm
Invites humility, and reminds us
We cannot control our lives.

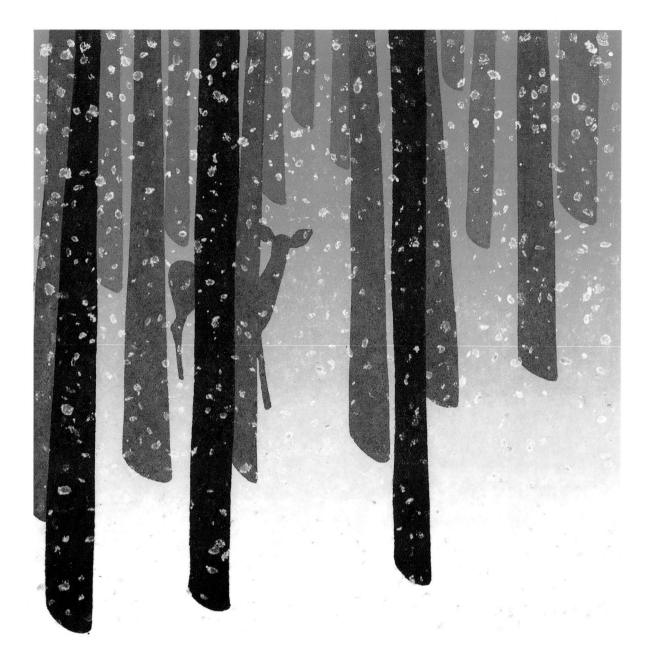

Otters

Sleek, their shadows flowing in pursuit,
Three otters slid
And climbed and slid again
Down the bank and onto snow-iced pond,
Where spring sun, high and hot at noon,
Had altered crust to corn
Whose kernels spun beneath their streamlined bellies
Like rollers on conveyor belts.
Neither fishing at the outlet edge
Nor in the rushing stream nearby
Lured these belly sliders from the ecstasy of coasting!

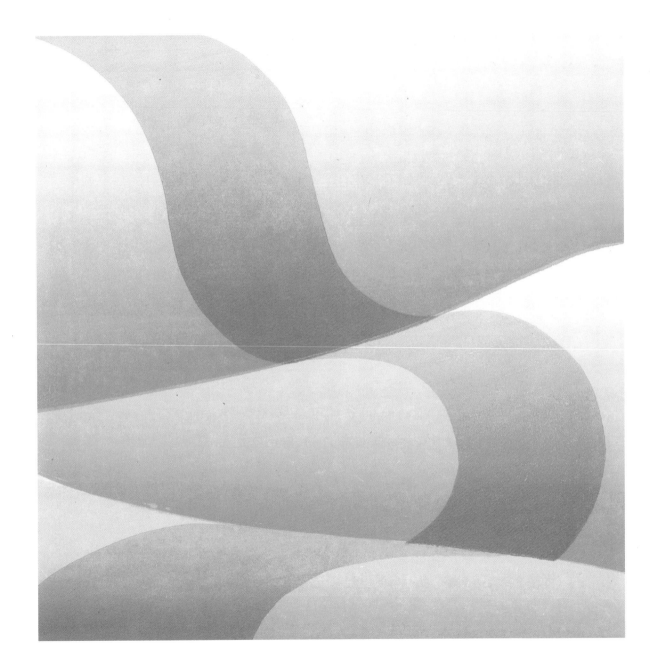

Impatient Spring

Suspended,
the earth waits for
impending
intending
portending
spring

to spring up
into grass and leaves and flowers
into spring-winged birds
plummeting across the sky in courtship chase
into frothing ponds
where urgent frogs in rapturous embrace
fulfill their calling

calling out in quacks and peeps
and later
plink
plank
plunks.

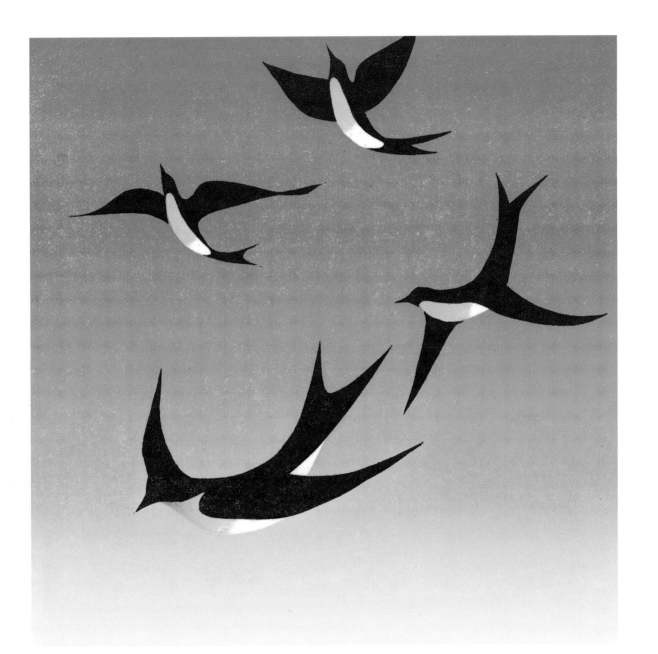

Waterfall

It's the distant sound that draws.
A pounding roar
That intrudes and then surrounds.
Swollen stream falling
From smooth-surfaced pool
Splashing, crashing
Into rock-strewn stream below.

The din and power of forest water
Plunging toward a distant sea
Drowns out the rest of life
And leaves one, mesmerized, alone.

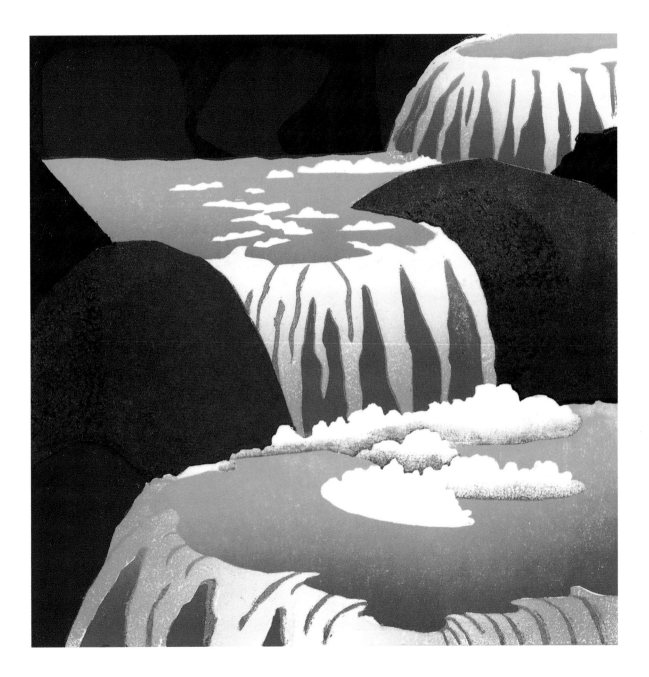

Summer Sky

Black on black,
Hills silhouetted in the night
Against a sky so limitless
Infinity seems real.
And we beneath the star-pricked sky
Are infinitesimal.

Yet we are also real.
Our senses, not bombarded
By the decibels and light
Of a frantic fearful world,
Are open
 - to the softest sound
 - to outlines and slight motion
 - to scents that rise
and float on dew-filled air.

Reduced, expanded,
We redeem essential selves.

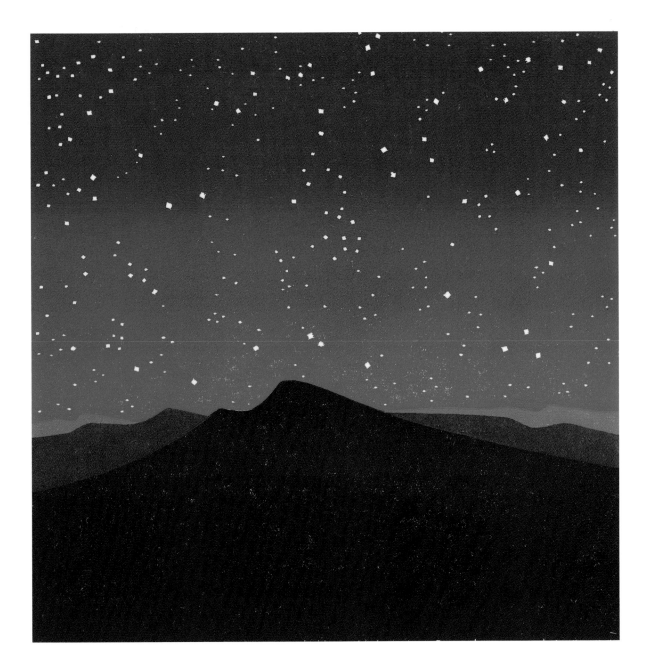

ORIGINS OF THE BOOK

Neighbors and friends for twenty-five years in East Barnard, Vermont, we collaborated on the cover of a Christmas Eve church program in 1981: a Sabra Field image overlaid with a Jenepher Lingelbach poem. In 1996, we co-chaired an Open Spaces committee working with other towns-people to define and preserve the rural quality of the town—open spaces and village communities. The urgency we feel about planning for the future use of the land initiated *Before Life Hurries On.*

Jenepher wrote the poems first, and Sabra created the scenes in response, not mirroring but capturing an image. We wanted to portray different times of day, seasons, nearby sights, and distant views. These fell naturally into the twelve months of the year, revealing both nature's calendar and our own.

The scenes and experiences we have portrayed are familiar to us both, but our senses give us different messages. Below, Jenepher explains what experiences inspired the poems, and Sabra describes her thoughts as she created the images.

Double Lives

Poem: A favorite walk in our village goes across a field and up a steep wooded slope to an open hilltop. Returning on the same path to the village, immersed in shadowy beech and maple woods, I am always startled to break out into sudden sunlight and see fields, houses, and the church.

Image: This is a view from memory. I tried to make all the parts lock together so the surface pattern works. It is an exercise in the geometry of land and man.

Morning Pond

Poem: We pass this pond almost daily. I have canoed and skated here, hiked around it and on the hills above it, and sat and watched and listened from all parts of its shoreline.

Image: The slightest undulation in the pond sets mirrored cattails wavering. I wanted so much to make this image *without* the cattails, with only the evidence of them in the upside-down world.

Mountain Top

Poem: A recent climb up Vermont's Camel's Hump mountain left the images of sheep-like clouds and black water rippled gold. The soft twitters of songbirds surprised me; they seemed out of place with the stunted stiff foliage and barren rocks. Yet mountain tops are crucial nesting habitats for some songbirds.

Image: Our old mountains create a ripple across the horizon reminding us of the ages before time. Greens turn to blues as they recede into the distance and touch the sky, where they are repeated in the fanciful mountain forms of the clouds, which in turn cast rippling shadows down upon the forest. I don't let a summer go by without a hike up to the top of our highest bald hill, where I can see from Ascutney to Camel's Hump.

Autumn Dawn

Poem: Sometime in August a morning comes when the mist rises from the White River and rolls up into our valley, obscuring the distant hills—a sign that fall is coming. It is against these hills that this poem takes place.

Image: Maple leaves scud, swirl up, then descend—confetti that makes a Persian carpet on the ground.

November Fog

Poem: I had just reread some of Annie Dillard's *Pilgrim at Tinker Creek* where she described a brief eye encounter with a weasel. A day later, we stopped beside a country road in near zero visibility. Through dense fog, the poem's scene slowly came into focus. Annie Dillard's eye for detail sharpened my own. Where I had seen only ragged stumps, I gradually and with disbelief became aware of the feeding geese.

Image: Canada geese have become less and less welcome as they have become more and more successful in adapting to man's environment. But I love the flights of geese that touch down here to feed in the corn fields on their way south each autumn. They are a reminder that what is lost will come again. As they did to my ancestors on the rocky islands of the north Atlantic, they symbolize for me the promise of rebirth.

Early Winter

Poem: I respond to short days and cloudy skies of late fall and early winter with a lethargy—until I get out into the woods. There my senses take over—the sounds of wind, snow and ice brushing against the trees, animal signs on the snow—and my life energy returns.

Image: After all color seems lost, there are beech leaves, the blossoms of winter. Papery, they rustle quietly 'til buds unfurl the following spring and force the leaves to fall. The subtlety of the color eluded me until I picked a branch to bring into the studio.

Full Moon Night

Poem: In the heart of winter, a clear cold full moon night stirs someone in the village to goad the rest of us away from cozy stoves and out for a night ski. One special crystal night, twenty below zero, inspired this poem as I saw the shadows of the skiers ahead of me moving silently up the slope.

Image: Snow cover abstracts the world. Night removes all detail. Then the klieg light of the moon illuminates the scene.

Winter Storm

Poem: The woods are different in a snow storm—still, like an old black and white photograph, silent except for sissing sounds of snow hitting branches. I like to watch the snowflakes fall through naked branches or filter slowly, screened by tiny-needled hemlock boughs.

Image: Dark and cold, the quiet filling up of snow among the trees. We may never see a deer, but our imaginations fill out the details.

Otters

Poem: A favorite memory is of a pair of otters swimming, diving, and rolling around our canoe one morning. I have also followed their tracks and found their snowslides. For me, they are a symbol of the joy of life.

Image: From the kitchen window one morning last winter, we saw otters playing on the bank of the stream that empties from our pond. Investigating later on skis, I discovered this record of their play.

Impatient Spring

Poem: In a March nature writing course, we were sent outdoors to write. I had nothing to say and sat, waiting. Eventually, I became aware of the chickadee overhead that was tipped half way around a branch to catch the dripping sap. The first outdoor fly of the spring buzzed past, and as my senses gained momentum, so did the pace of my writing. Impatient Spring burst forth.

Image: Above our pond on summer evenings, an ecstatic air ballet takes place as swallows swoop and plummet for the rising hatch.

Waterfall

Poem: The woods' road behind the house passes by a small waterfall. After heavy rains, the roar of the water is audible from far away. I go there often—in summer when the water barely trickles over the mossy rocks, in winter when it gurgles under an icy apron.

Image: When Jenepher and I climb Royalton Mountain, the brook comes toward us, pouring from pool to pool. Afterward, I try to remember how the water moves down each step by thinking of white fingers splayed with darkness in between. Jenepher says she wants her ashes scattered in a place like this, and I can understand for she is a forest person. I am a meadow person, so I will be content in the churchyard surrounded by a hayfield.

Summer Sky

Poem: I like to walk without a flashlight, allowing my pupils to dilate to their fullest. I relish waves of warm and cooler air as I walk down to the pond on a hot night. I look at the night sky to see which way the dipper is hanging, where Orion is running in winter, and if my eyes stay soft, perhaps a shooting star.

Image: We *do* know, those of us who live beyond the range of city glow, how fortunate we are to have the stars for company at night. They reassure us that behind each earthly day, the cosmos ticks along as God intends.

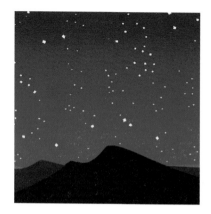

UNIVERSITY PRESS OF NEW ENGLAND publishes books under its own imprint and is the publisher for Brandeis University Press, Dartmouth College, Middlebury College Press, University of New Hampshire, Tufts University, and Wesleyan University Press.

LIBRARY OF CONGRESS CATALOGING-IN-PUBLICATION DATA
Field, Sabra.
 Before life hurries on / by Sabra Field and Jenepher Lingelbach.
 p. cm.
 ISBN 0–87451–911–X (alk. paper)
 1. Natural history—Vermont—Poetry. 2. Nature—Poetry.
I. Lingelbach, Jenepher, 1935– . II. Title.
PS3556.I3965B44 1999
811'.54—dc21
 98–51450